TURN-OF-THE-CENTURY
TILE DESIGNS
IN FULL COLOR

L. François

DOVER PUBLICATIONS, INC.
MINEOLA, NEW YORK

Bibliographical Note

This book is a partial reproduction of *La Céramique Architecturale/Revêtements Décoration: Album de Carreaux pour Revêtements* (Architectural Ceramics/Wall Decoration: [An] Album of Wall Tiles), a trade catalog published by the ceramics manufacturer Faïenceries de Serraguemines, Digoin et Vitry-le-François/Utzschneider & Cie., Paris, 1905.

DOVER *Pictorial Archive* SERIES

Library of Congress Cataloging-in-Publication Data

Faïenceries de Sarreguemines, Digoin et Vitry-le-François.
 [Céramique architecturale. English. Selections]
 Turn-of-the-century tile designs in full color.
 p. cm. — (Dover pictorial archive series)
 Originally published: Paris : Faïenceries de Sarreguemines, Digoin et Vitry-le-François, 1905.
 A partial reproduction of: La céramique architecturale: revêtements, décoration.
 ISBN 0-486-41525-2 (pbk.)
 1. Tiles—France—Catalogs. 2. Decoration and ornament, Architectural—France—Catalogs. 3. Decoration and ornament—France—Art nouveau—Catalogs. 4. Faïenceries de Sarreguemines, Digoin et Vitry-le-François—Catalogs. I. Title. II. Series.

NA3705 .F35 2001
738.6'0944'075—dc21
 2001028593

Manufactured in the United States of America
Dover Publications, Inc., 31 East 2nd Street, Mineola, N.Y. 11501

NOTE

The tiles, panels, signs and decorations reproduced in this book are taken from a trade catalog of architectural ceramics published in 1905 by Les Faïenceries de Sarreguemines, Digoin et Vitry-le-François, a company that is still in business today. These items, produced for the French construction trade, represent what looks now like an aesthetic high point for commercially produced ceramic tile. Not intended as art (though some of the panels were designed by named artists), these Art Nouveau creations—those that survive—are prized for their beauty and their charm. This charm has a large component of nostalgia, evoking as it does the *Belle Époque* and what we might prefer to think, if only on the basis of these stylish artifacts, was its more civilized society. Whether it was so in fact is debatable, but certainly in an age of universal linoleum-floored, recessed-fluorescent-lighted, acoustical-tile-drop-ceilinged, sheetrock-walled charmlessness, who wouldn't prefer such merciful "amenities" (as they are called these days) as ordinary commercial spaces adorned with multicolored tile—check patterns, friezes of cats or peaches, borders of enamel daisies or lilies, images of placid-looking sheep or sinuously verdant gardens populated with birds, and perhaps an allegorical figure of Beer, or The Harvest. This decor may not have been as common as linoleum and drop ceilings are today, but neither was it exclusively to be found in the metropolitan resorts of the posh and the *nouveau riche*. This catalog is the proof.

Art Nouveau as a decorative style was applied to every possible medium, from architecture to silverware, most famously, perhaps, in the entrance kiosks to the Paris Métro. It flourished in the 1890s and began to wane thereafter, so the tiles in this book come from a period when the style had been popular for some time and was perhaps even a bit passé. (Tiled surfaces and decorations were not unique to Art Nouveau, of course, but they do seem to have been well adapted to it.) The 1905 catalog lists an impressive number of public spaces and buildings in which the company's ceramic decor was an integral feature, including government buildings, hotels, railroad stations, casinos, "thermal establishments," hospitals, schools, department stores and restaurants. The catalog offered a fair selection of what it could provide ready-made to those furnishing bistros, butcher shops, bakeries, even (admittedly not humble) private homes, who would thus have had the opportunity to apply some of the same grand style in their own more modest establishments.

We, of course, can only wish that our own modest establishments had a similar opportunity, but no such luck. They don't make them like that anymore. So much the worse for us.

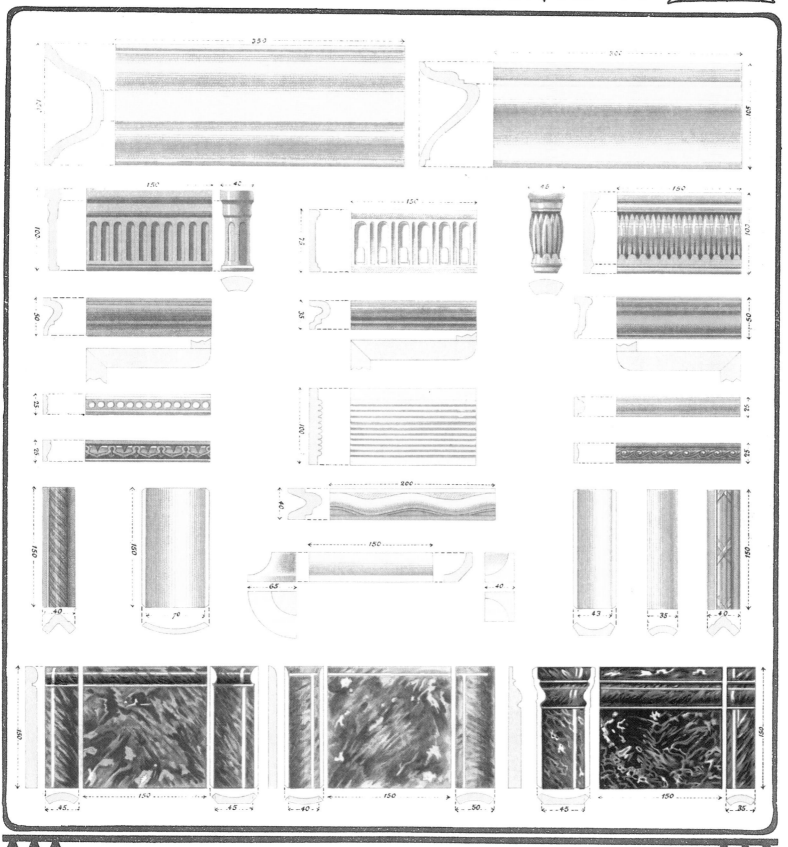

28, RUE DE PARADIS – PARIS

1. Moldings in various shapes

LES FAÏENCERIES DE SARREGUEMINES
DIGOIN ET VITRY·LE·FRANÇOIS

TÉLEPHONE
258·70

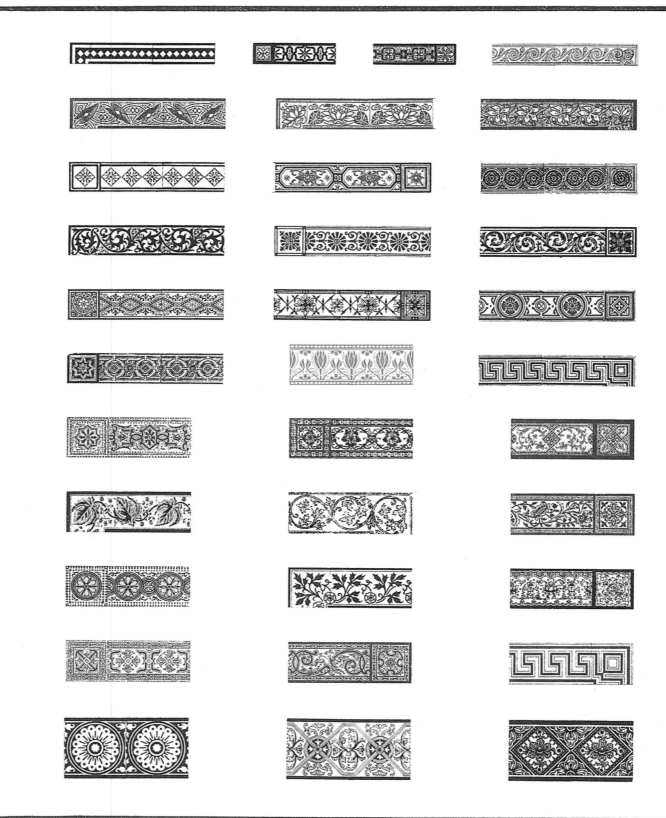

28, RUE DE PARADIS — PARIS

2. Molded borders in single and multiple colors

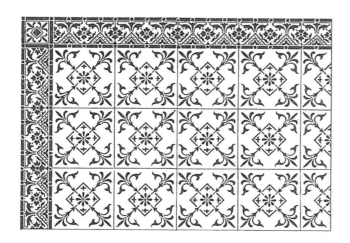

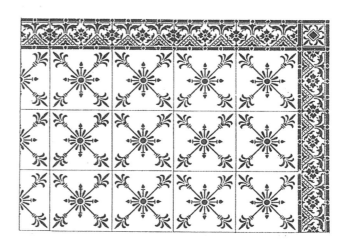

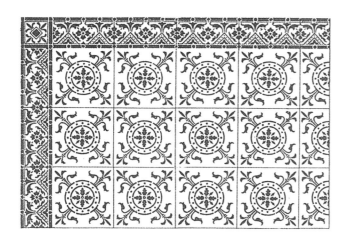

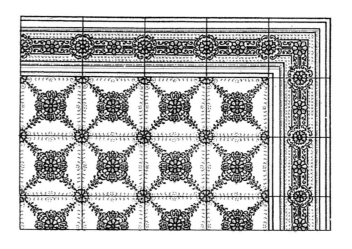

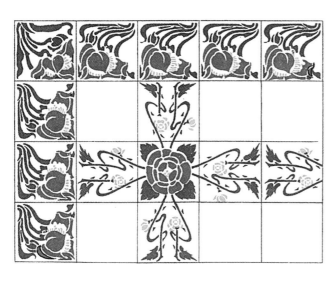

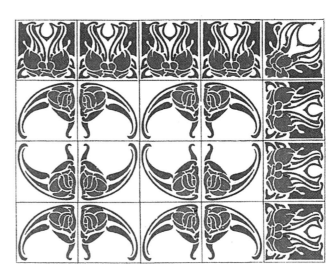

28, RUE DE PARADIS _ PARIS

3. Tiles stenciled in single or multiple colors on a white and ivory background

Gᵈ PRIX
1900

LES FAÏENCERIES DE SARREGUEMINES
DIGOIN ET VITRY·LE·FRANÇOIS

TÉLÉPHONE
258·70

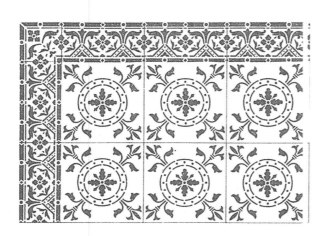

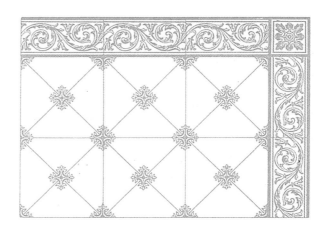

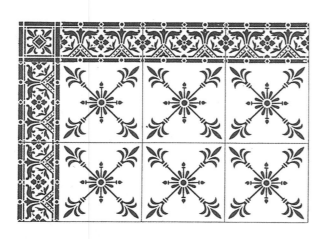

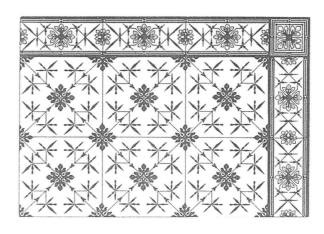

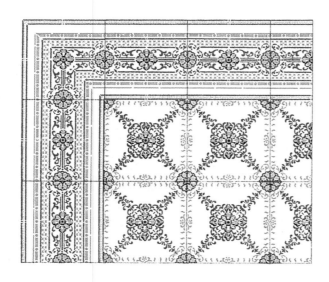

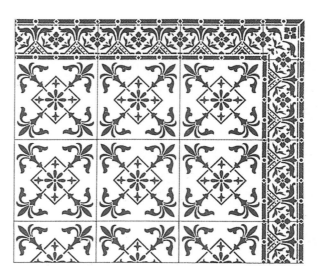

28, RUE DE PARADIS _ PARIS

4. Molded tiles stenciled in single or multiple colors

LES FAÏENCERIES DE SARREGUEMINES
DIGOIN ET VITRY·LE·FRANÇOIS

TÉLÉPHONE
258·70

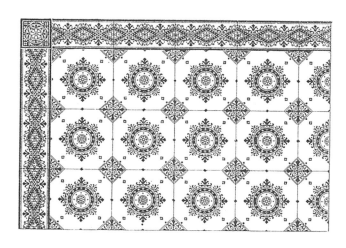

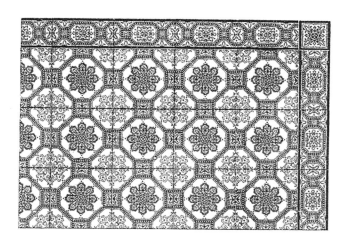

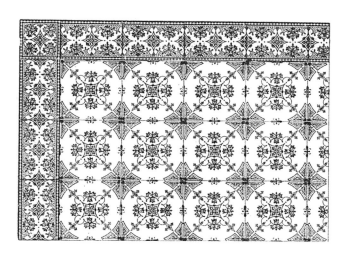

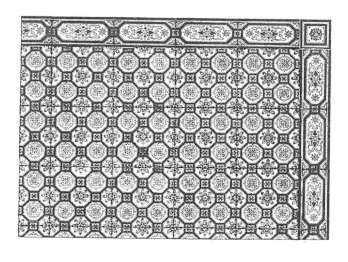

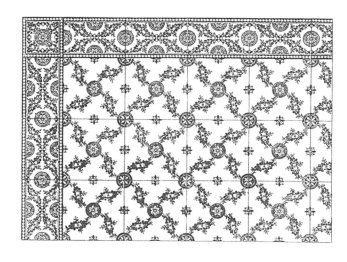

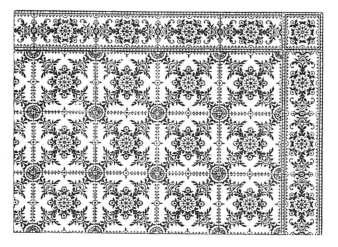

28, RUE DE PARADIS - PARIS

5. Molded tiles in single or multiple colors

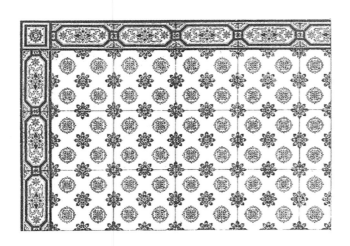

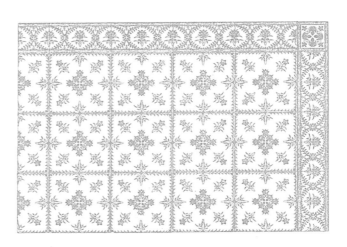

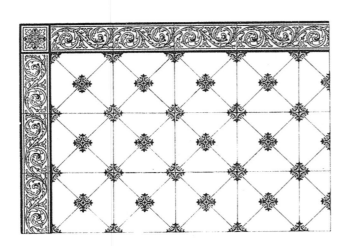

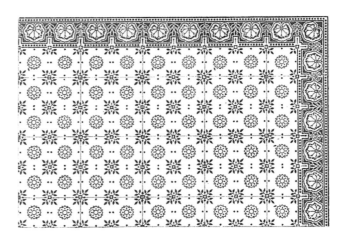

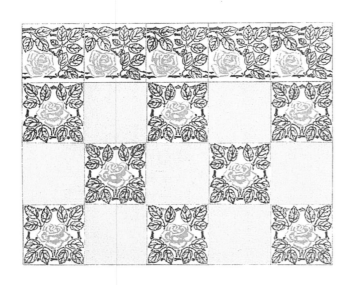

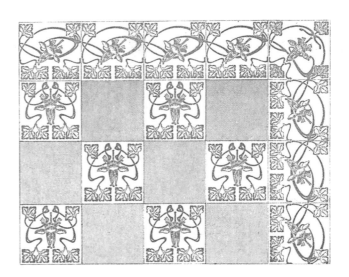

28, RUE DE PARADIS – PARIS

6. Molded tiles in single or multiple colors

LES FAÏENCERIES DE SARREGUEMINES
DIGOIN ET VITRY·LE·FRANÇOIS

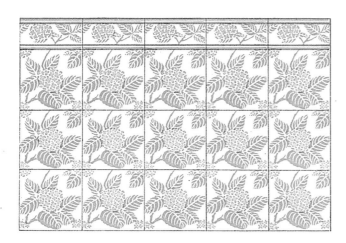

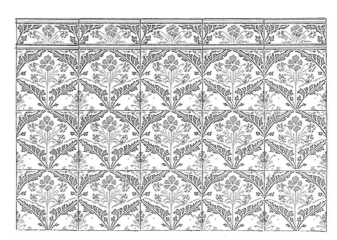

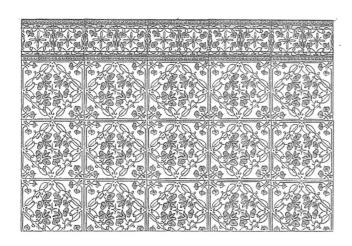

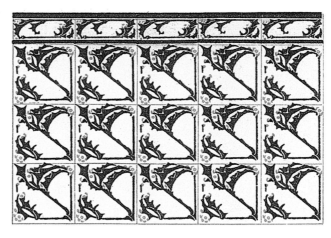

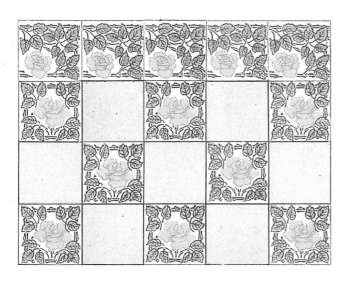

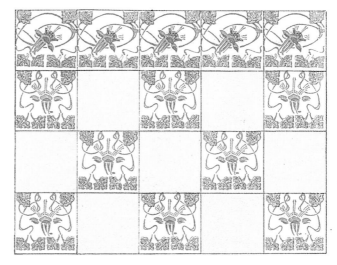

28, RUE DE PARADIS _ PARIS

7. Molded tiles in single or multiple colors

Gᵈ PRIX
1900

LES FAÏENCERIES DE SARREGUEMINES
DIGOIN ET VITRY·LE·FRANÇOIS

TÉLEPHONE
258·70

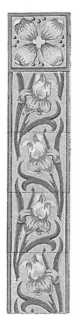
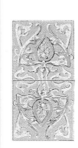
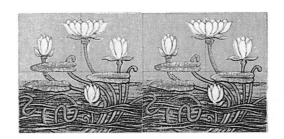
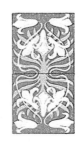
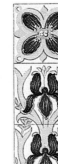
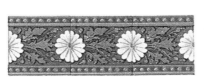
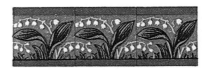
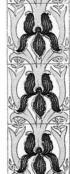
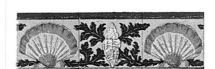
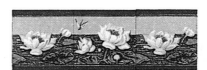
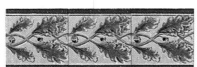
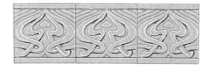
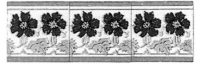
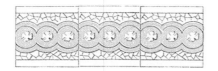
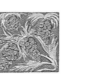
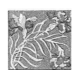
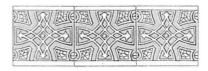
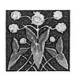

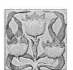
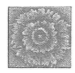
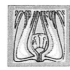
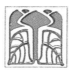
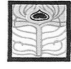
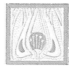
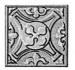
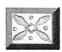
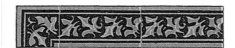
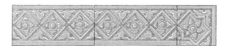
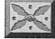

28, RUE DE PARADIS – PARIS

8. Friezes and reliefs

G.º PRIX
1900

LES FAÏENCERIES DE SARREGUEMINES
DIGOIN ET VITRY·LE·FRANÇOIS

TÉLÉPHONE
258·70

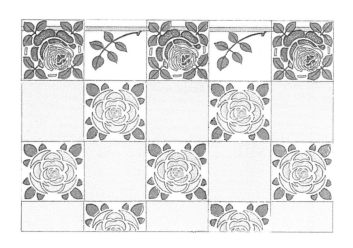

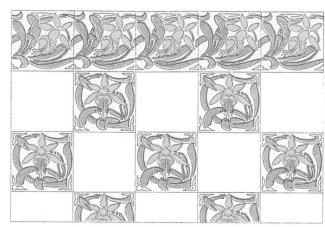

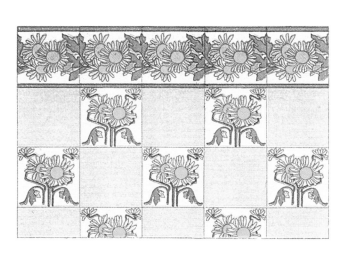

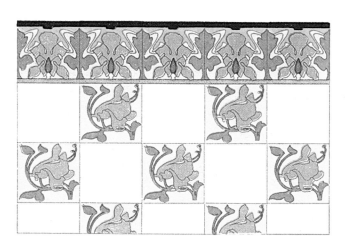

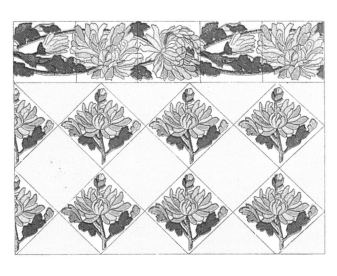

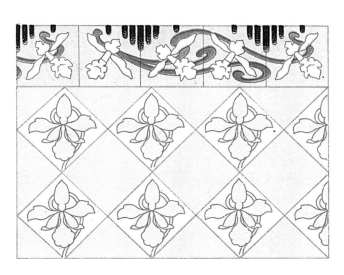

28, RUE DE PARADIS — PARIS

9. Combinations of plain and painted enamel tiles in checkerboard pattern

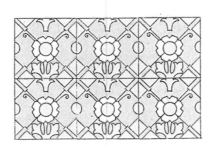
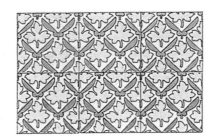
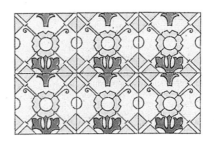
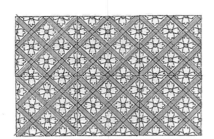
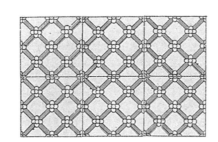
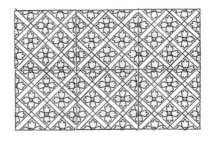
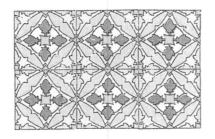
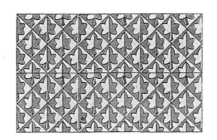
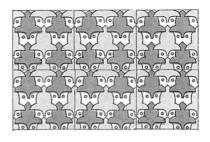
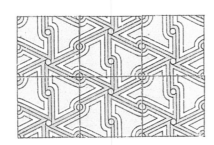
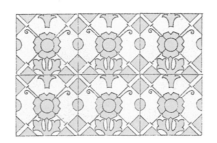
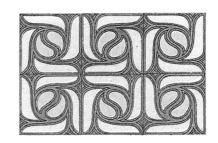

28, RUE DE PARADIS – PARIS

10. Background patterns in painted enamel

LES FAÏENCERIES DE SARREGUEMINES
≥≥ DIGOIN ET VITRY·LE·FRANÇOIS ≤≤

G? PRIX
1900

TÉLÉPHONE
258·70

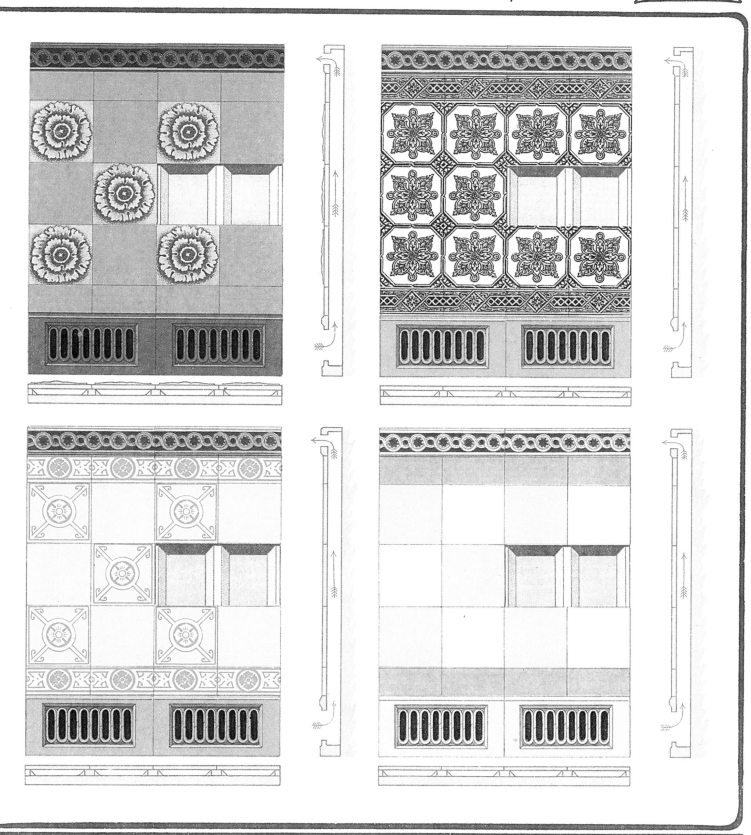

28, RUE DE PARADIS - PARIS

11. Tile-fronted hollow wall for ventilation

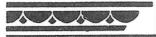

LES FAÏENCERIES DE SARREGUEMINES
❦ DIGOIN ET VITRY·LE·FRANÇOIS ❦

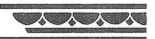
TÉLEPHONE 258·70

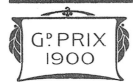

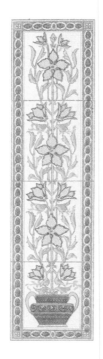

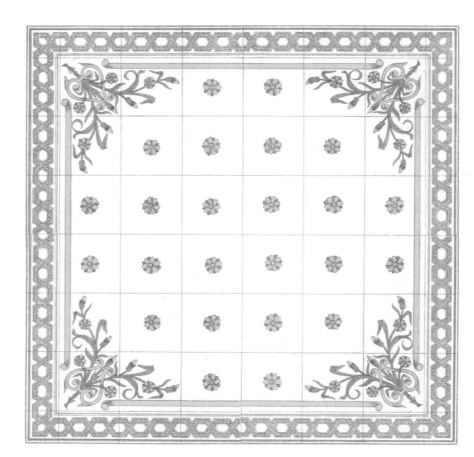

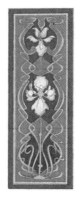

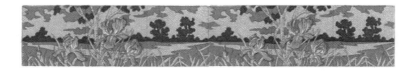

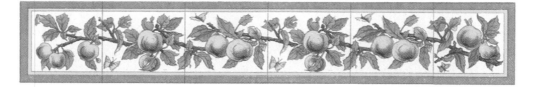

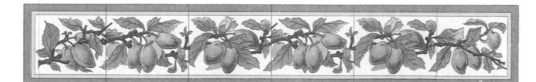

28, RUE DE PARADIS - PARIS

12. Multicolor molded-tile panel, friezes and mountings

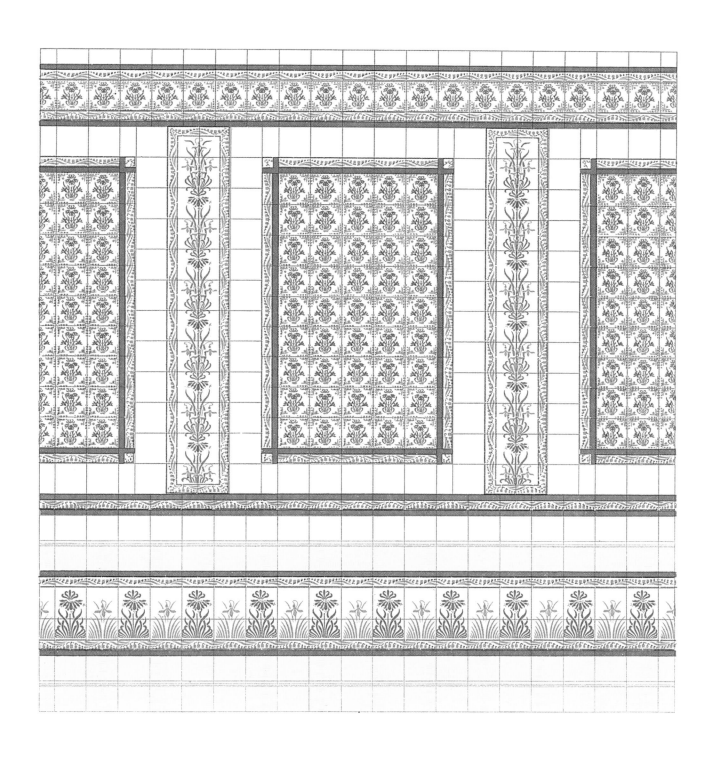

13. Combination of plain with stenciled multicolor tile

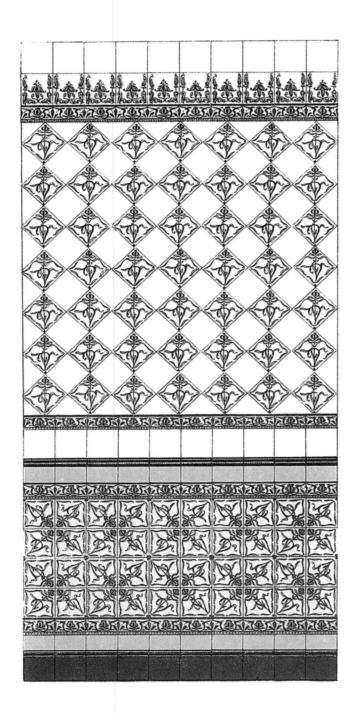

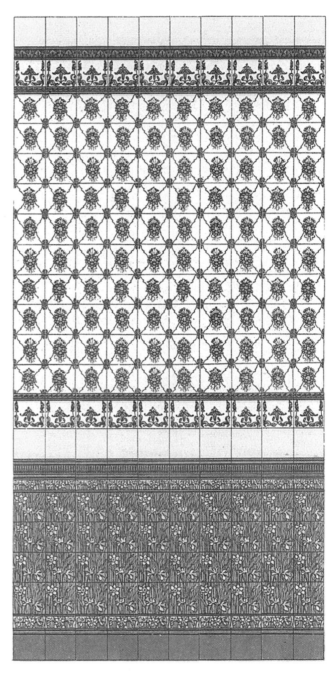

28, RUE DE PARADIS - PARIS

14. Combinations of plain with single and multicolor molded tile

LES FAÏENCERIES DE SARREGUEMINES
DIGOIN ET VITRY·LE·FRANÇOIS

G° PRIX 1900

TELEPHONE 258 70

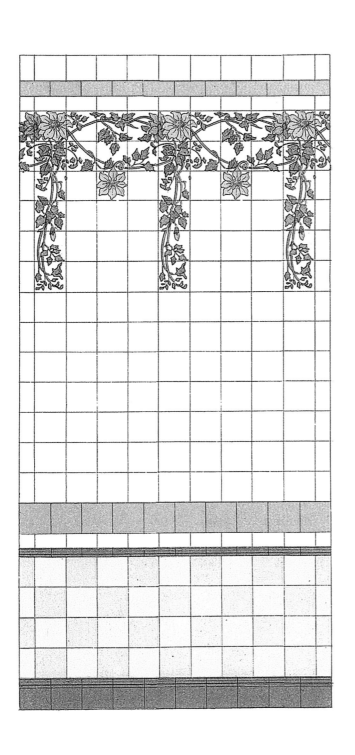

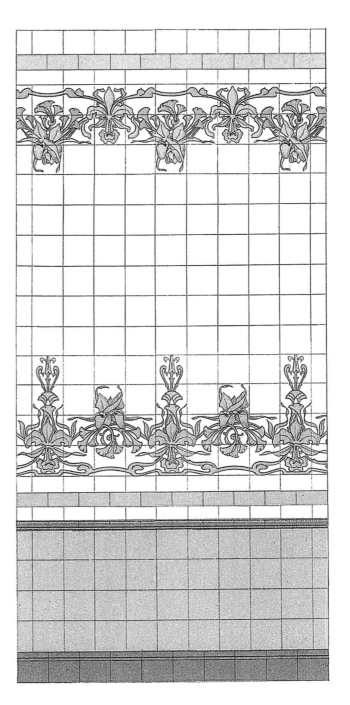

28, RUE DE PARADIS – PARIS

15. Combinations of plain with painted enamel tile

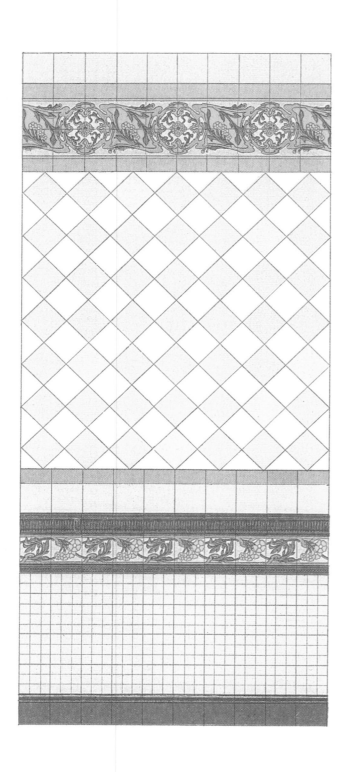

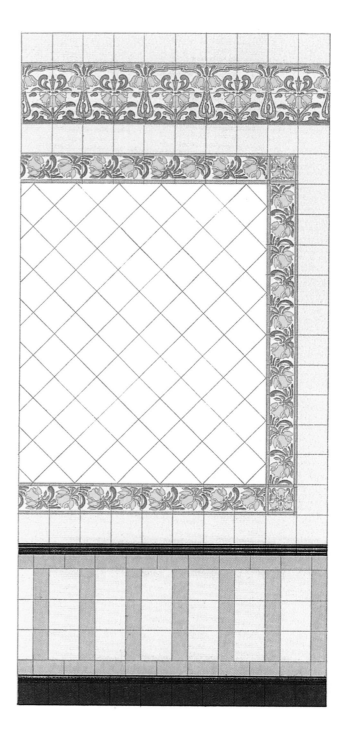

28, RUE DE PARADIS - PARIS

16. Combinations of plain with painted enamel tile borders

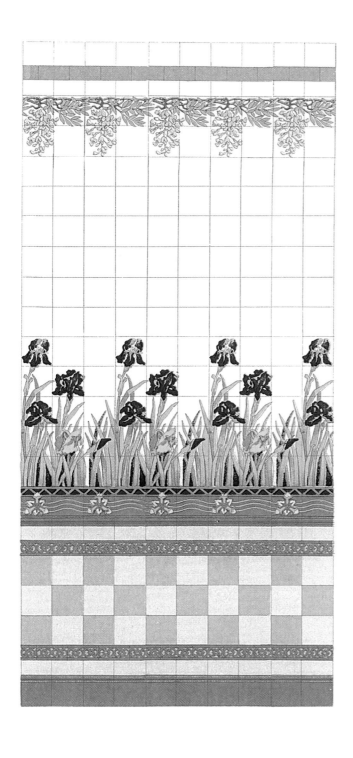

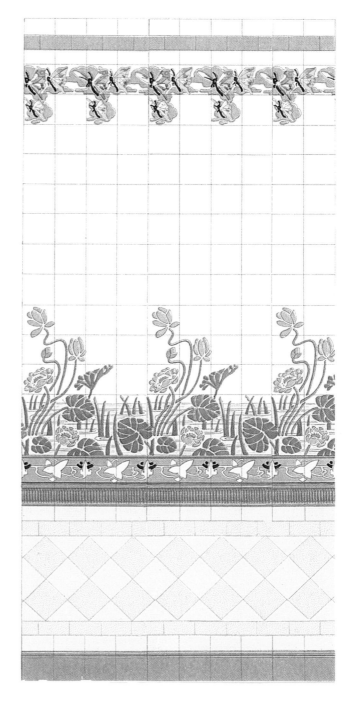

28, RUE DE PARADIS _ PARIS

17. Combinations of plain with painted enamel tile

LES FAÏENCERIES DE SARREGUEMINES
DIGOIN ET VITRY·LE·FRANÇOIS

GᵈᵉPRIX 1900

TÉLEPHONE 258·70

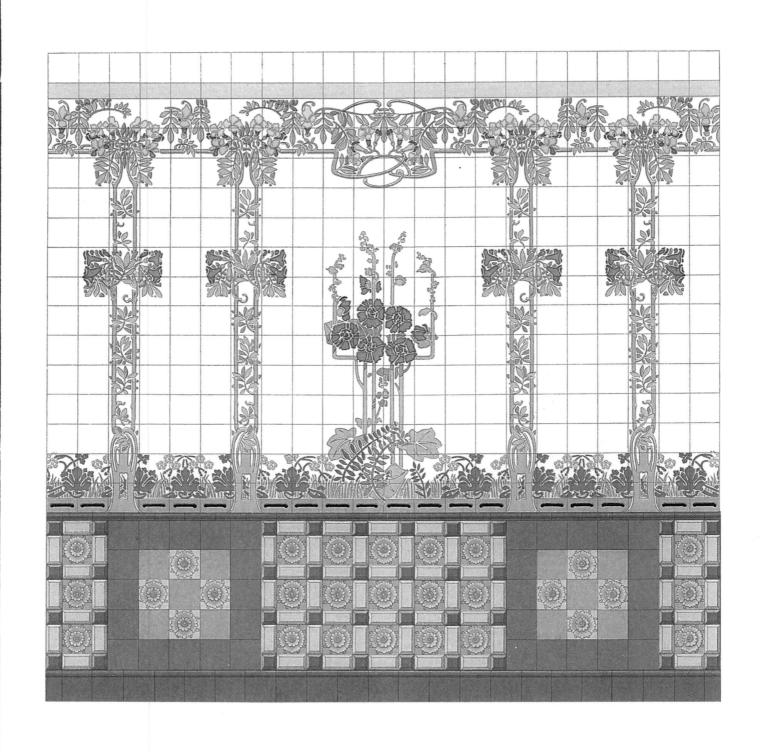

28, RUE DE PARADIS – PARIS

18. Combination of plain with painted enamel tile for conservatory, veranda, vestibule, etc.

G? PRIX
1900

LES FAÏENCERIES DE SARREGUEMINES
DIGOIN ET VITRY·LE·FRANÇOIS

TÉLÉPHONE
258·70

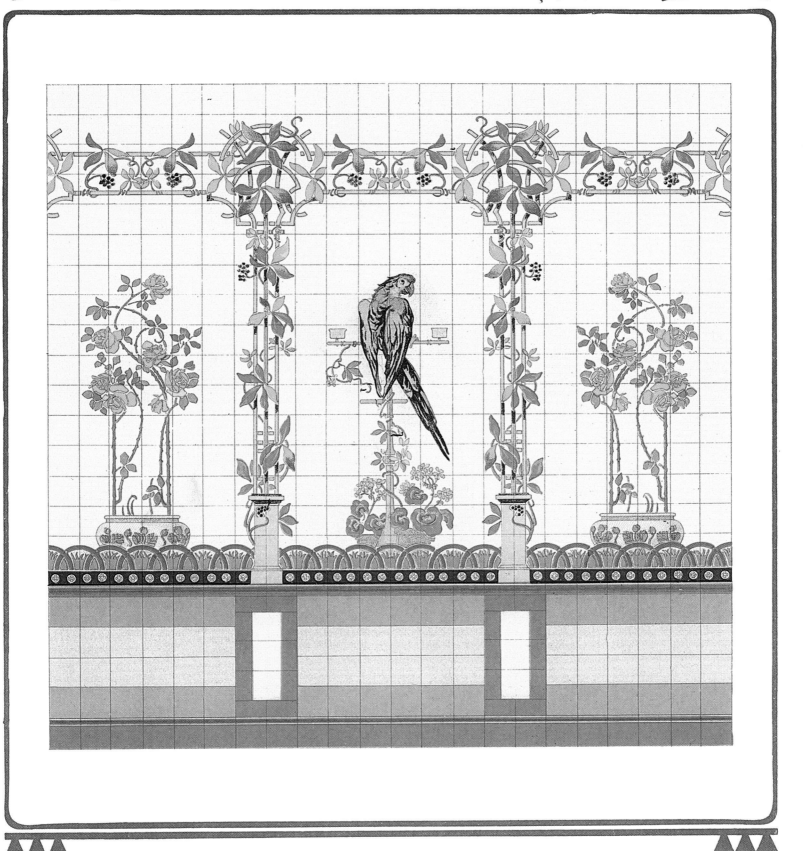

28, RUE DE PARADIS – PARIS

19. Combination of plain with painted enamel tile for conservatory, veranda, vestibule, etc.

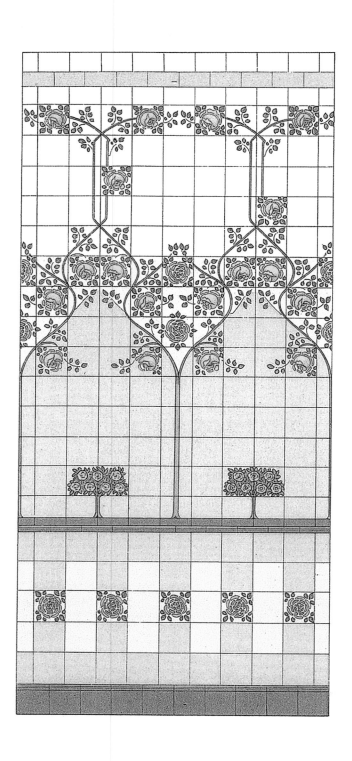

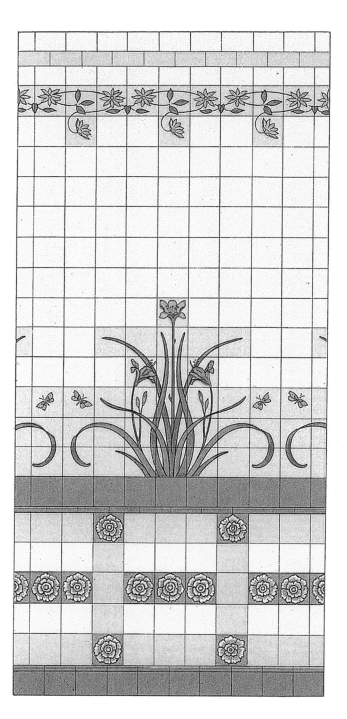

28, RUE DE PARADIS — PARIS

20. Combinations of plain with painted enamel tile

G? PRIX
1900

LES FAÏENCERIES DE SARREGUEMINES
DIGOIN ET VITRY·LE·FRANÇOIS

TÉLÉPHONE
258·70

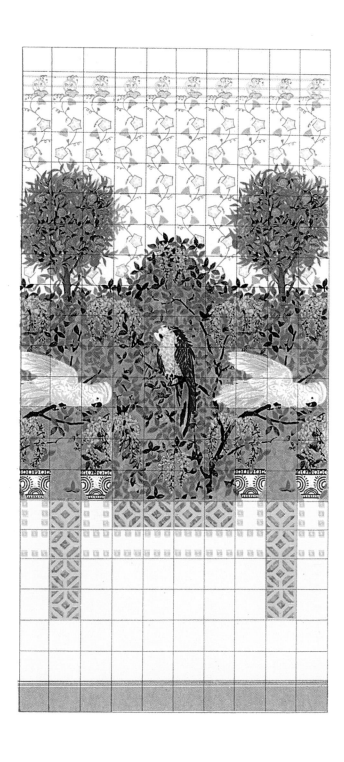

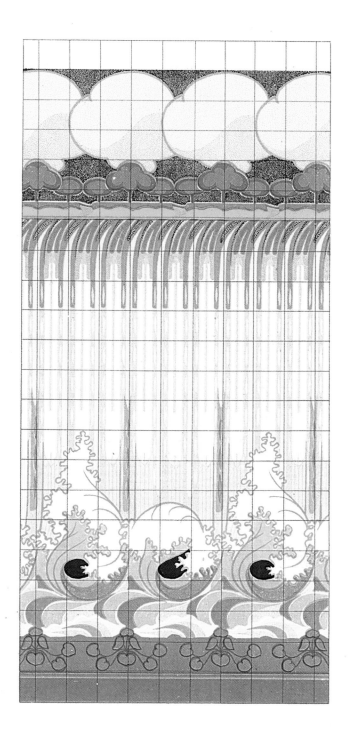

28, RUE DE PARADIS _ PARIS

21. Combinations of painted enamel tile

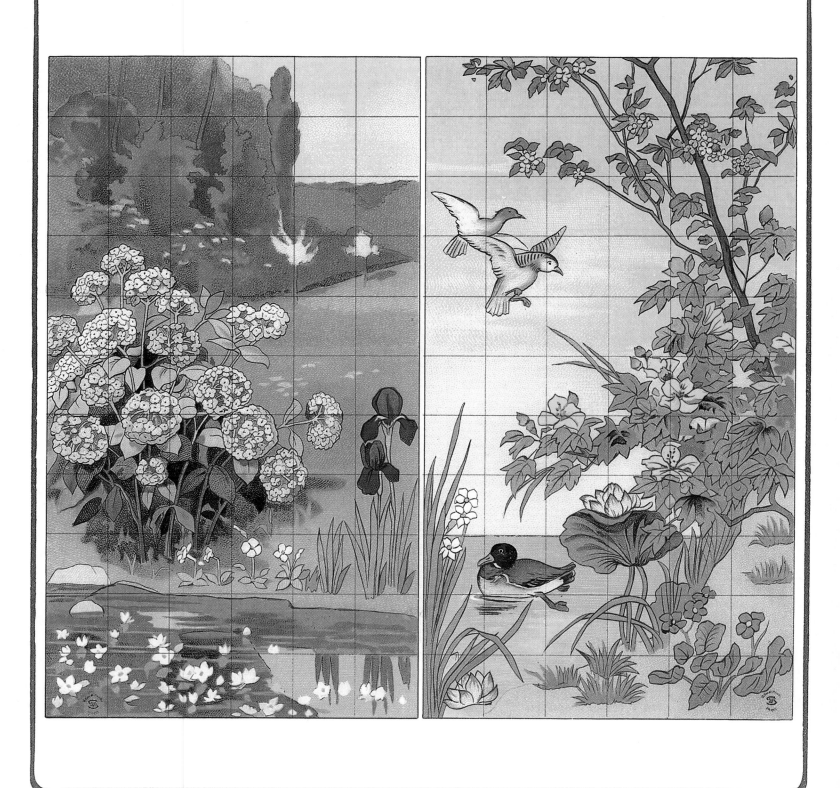

28, RUE DE PARADIS – PARIS

22. Decorative panels of all sizes in painted enamel, in stock designs or made to order

LES FAÏENCERIES DE SARREGUEMINES
DIGOIN ET VITRY·LE·FRANÇOIS

TÉLÉPHONE
258·70

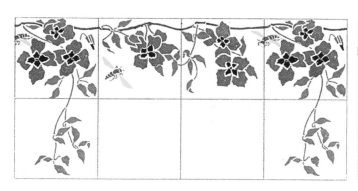
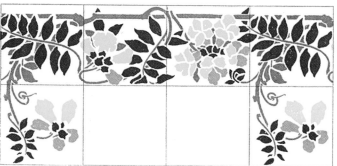

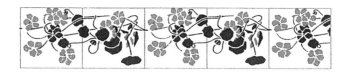
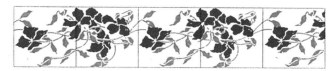

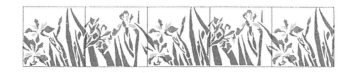
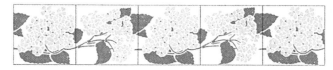

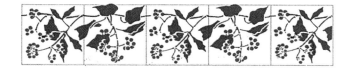
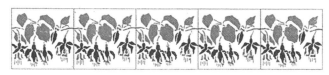

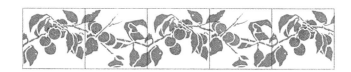
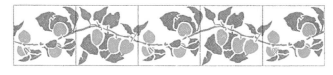

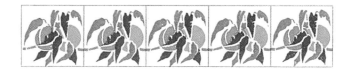
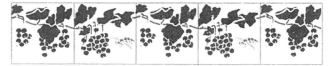

28, RUE DE PARADIS - PARIS

23. Multicolor stenciled friezes

LES FAÏENCERIES DE SARREGUEMINES
DIGOIN ET VITRY·LE·FRANÇOIS

G? PRIX 1900

TÉLÉPHONE 258·70

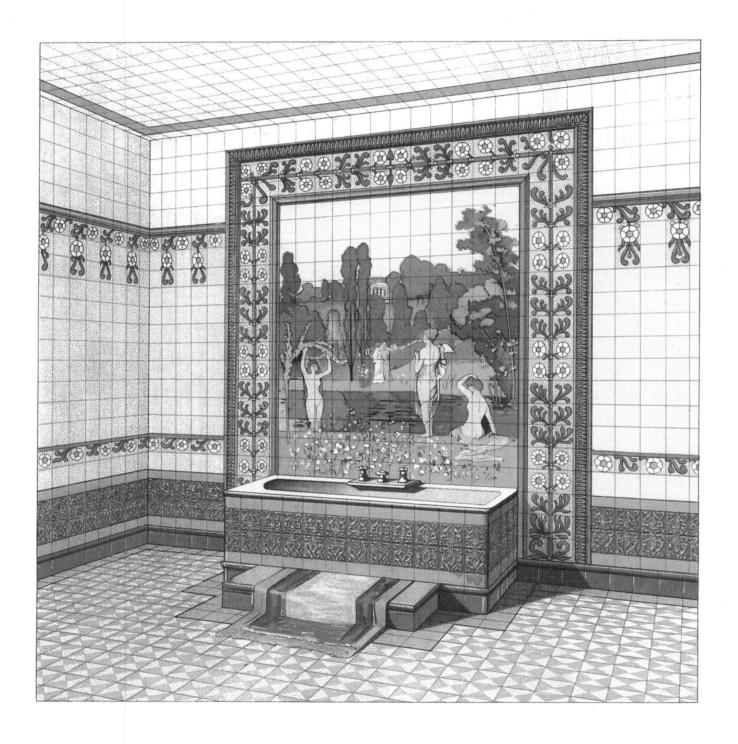

28, RUE DE PARADIS _ PARIS

24. Decorative walls for bathroom with tile facing for tub

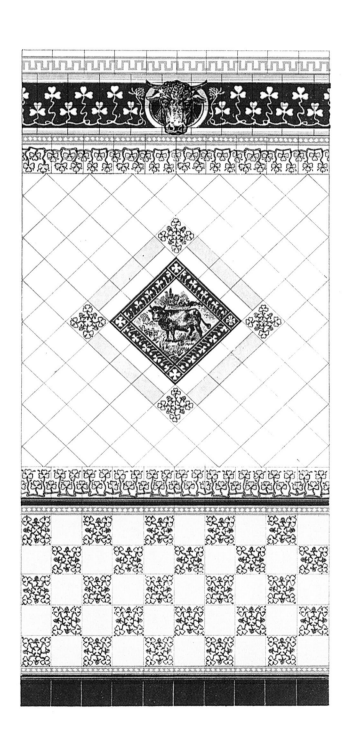

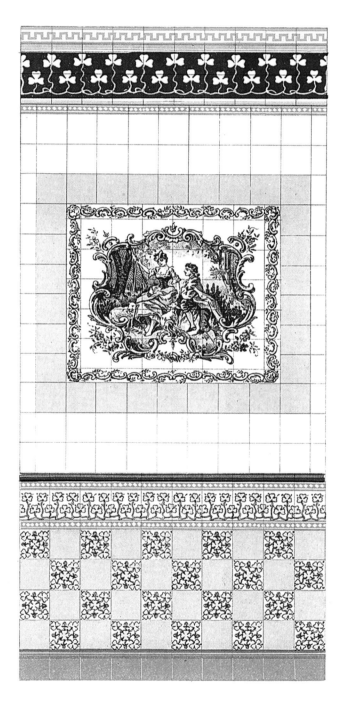

28, RUE DE PARADIS _ PARIS

25. Combinations of plain with single-color molded tile for businesses

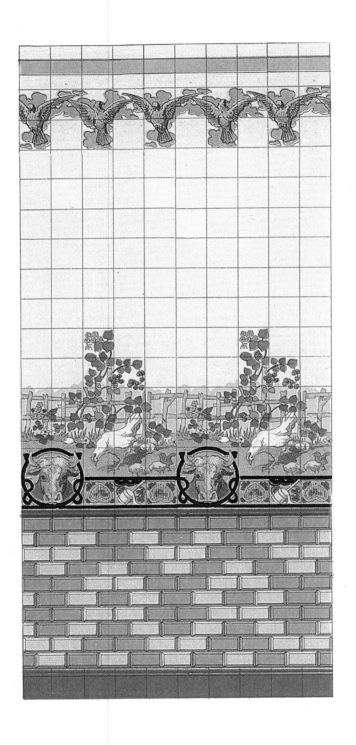
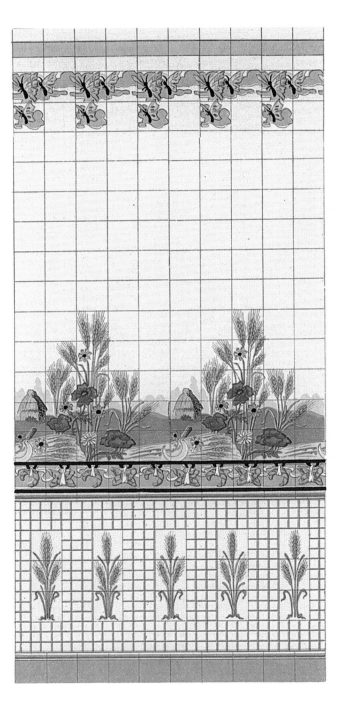

28, RUE DE PARADIS – PARIS

26. Combinations of plain with painted enamel tile for businesses

LES FAÏENCERIES DE SARREGUEMINES
DIGOIN ET VITRY·LE·FRANÇOIS

G.ᵉ PRIX
1900

TÉLÉPHONE
258 70

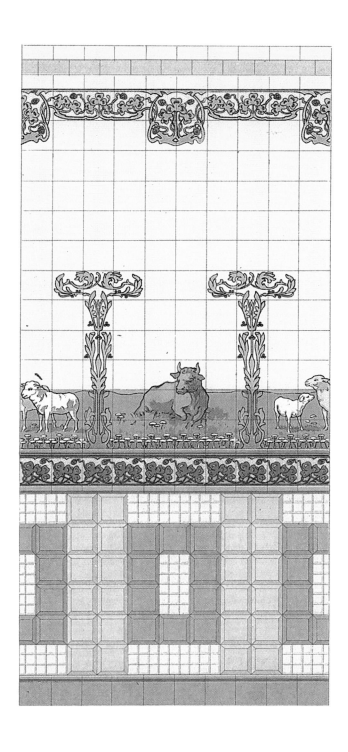

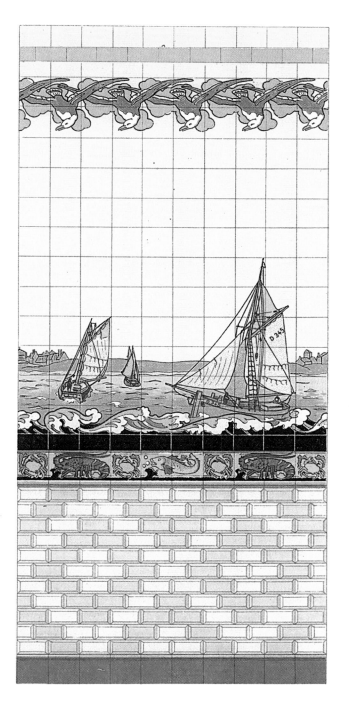

28. RUE DE PARADIS _ PARIS

27. Combinations of plain with painted enamel tile for businesses

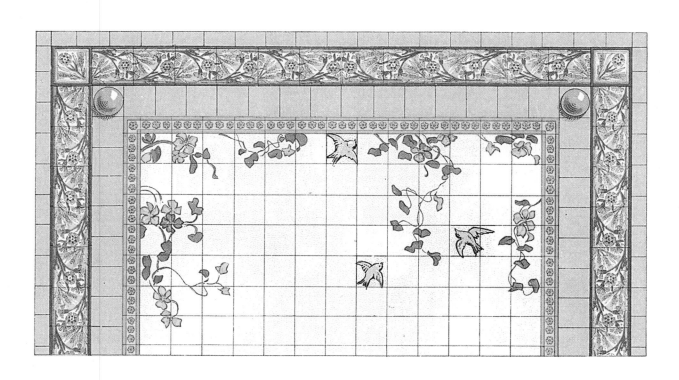

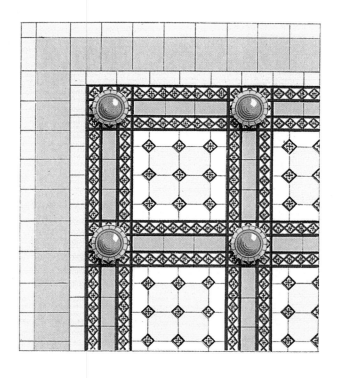

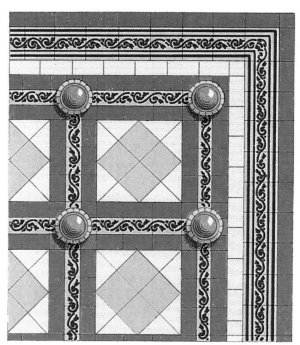

 28, RUE DE PARADIS – PARIS

28. Combinations of plain with patterned and painted tile and cabochons, for ceilings

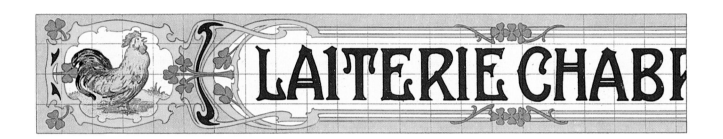

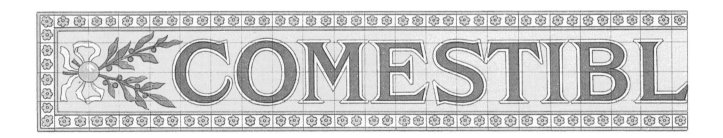

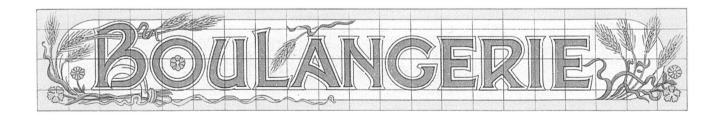

28, RUE DE PARADIS _ PARIS

29. Signs in painted enamel for businesses

LES FAÏENCERIES DE SARREGUEMINES
DIGOIN ET VITRY·LE·FRANÇOIS

NANTERRE

DÉFENSE
de descendre des voitures
avant l'arrêt complet du train

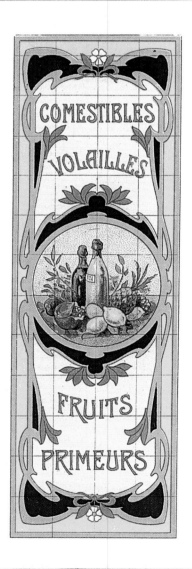

COMESTIBLES

VOLAILLES

FRUITS

PRIMEURS

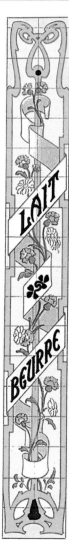

LAIT

BEURRE

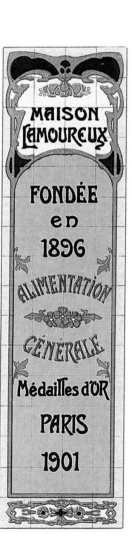

MAISON Lamoureux

FONDÉE en 1896

ALIMENTATION GÉNÉRALE

Médailles d'OR

PARIS 1901

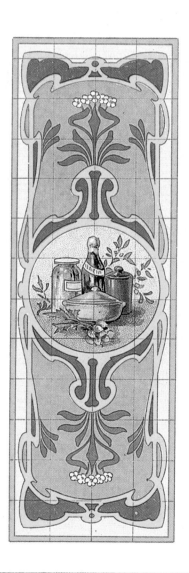

28. RUE DE PARADIS — PARIS

30. Panels and signs in painted enamel

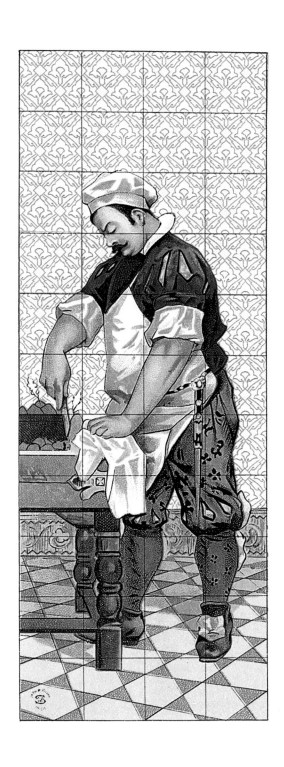

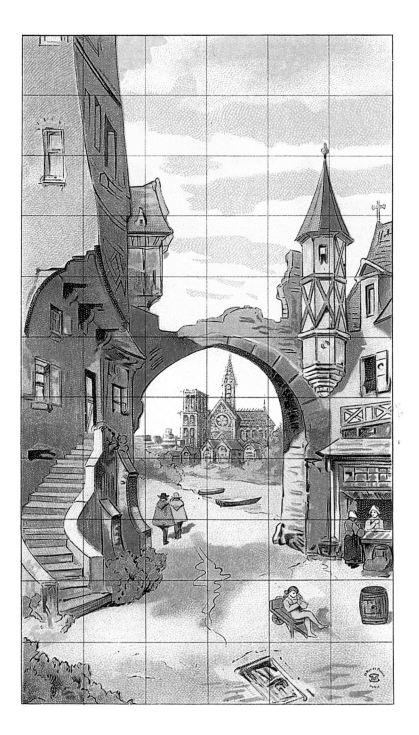

28, RUE DE PARADIS — PARIS

31. Decorative panels of all sizes in painted enamel, in stock designs or made to order

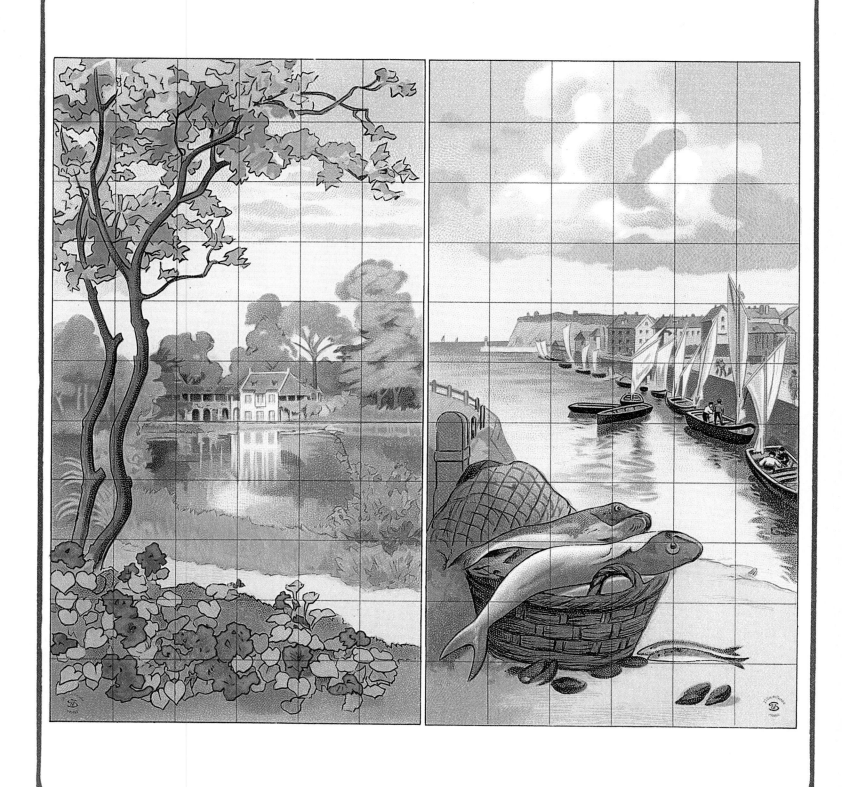

28, RUE DE PARADIS – PARIS

32. Decorative panels of all sizes in painted enamel, in stock designs or made to order

LES FAÏENCERIES DE SARREGUEMINES
DIGOIN ET VITRY·LE·FRANÇOIS

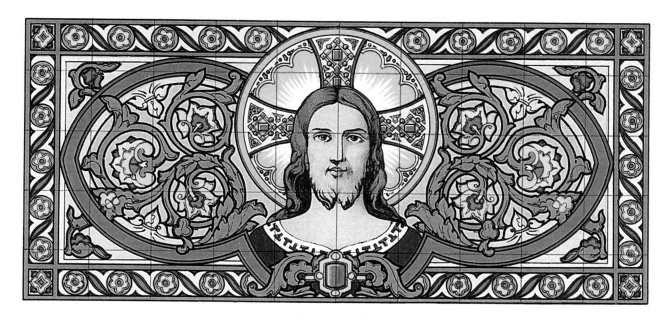

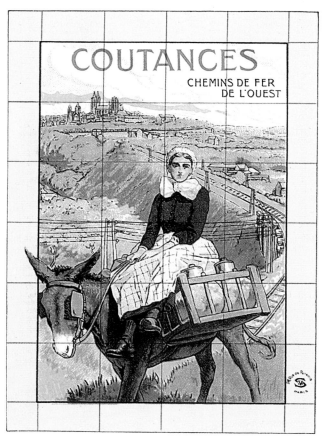

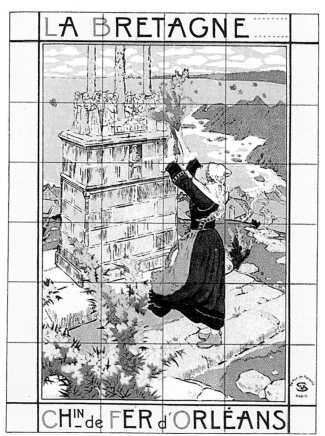

28, RUE DE PARADIS _ PARIS

33. Decorative panels of all sizes in painted enamel, in stock designs or made to order

LES FAÏENCERIES DE SARREGUEMINES
DIGOIN ET VITRY·LE·FRANÇOIS

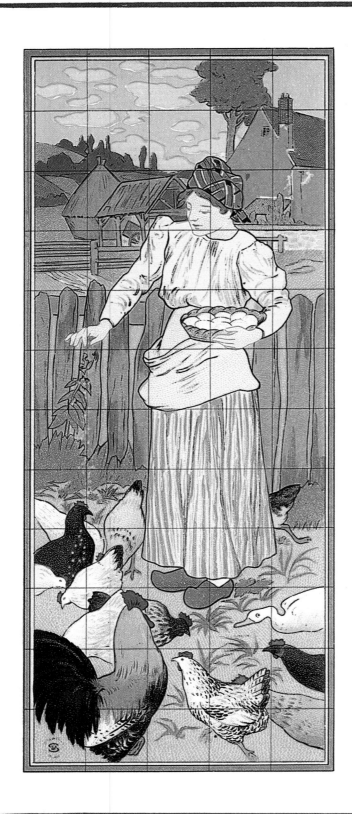

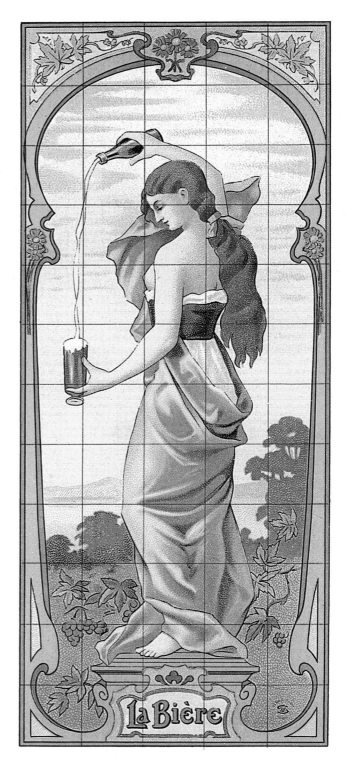

La Bière

28, RUE DE PARADIS – PARIS

34. Decorative panels of all sizes in painted enamel, in stock designs or made to order

LES FAÏENCERIES DE SARREGUEMINES
DIGOIN ET VITRY·LE·FRANÇOIS

TELEPHONE 258·70

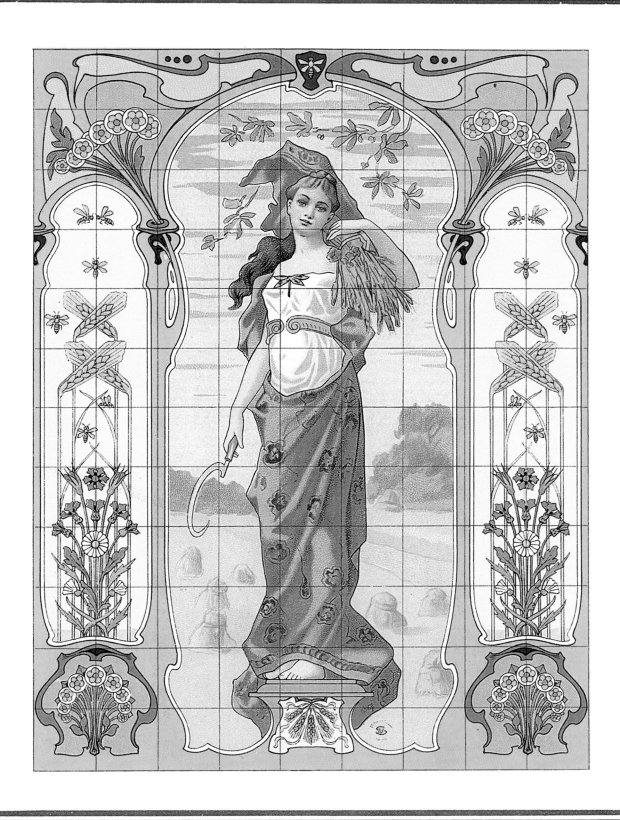

28, RUE DE PARADIS — PARIS

35. Decorative panels in painted enamel for businesses

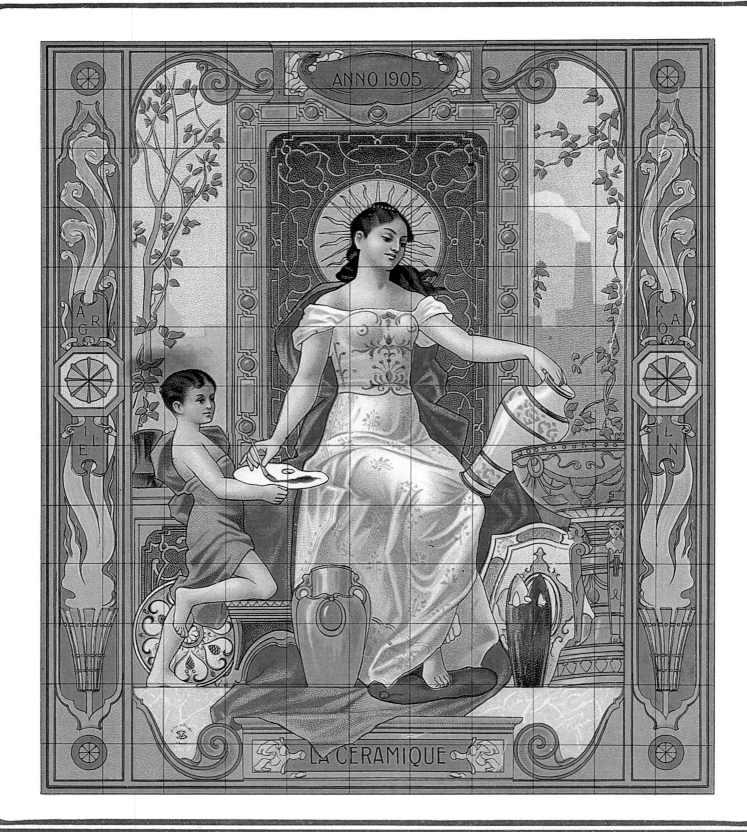

28, RUE DE PARADIS – PARIS

36. Allegorical panels of all sizes in painted enamel

LES FAÏENCERIES DE SARREGUEMINES
DIGOIN ET VITRY·LE·FRANÇOIS

Gᴰ PRIX
1900

TÉLÉPHONE
258·70

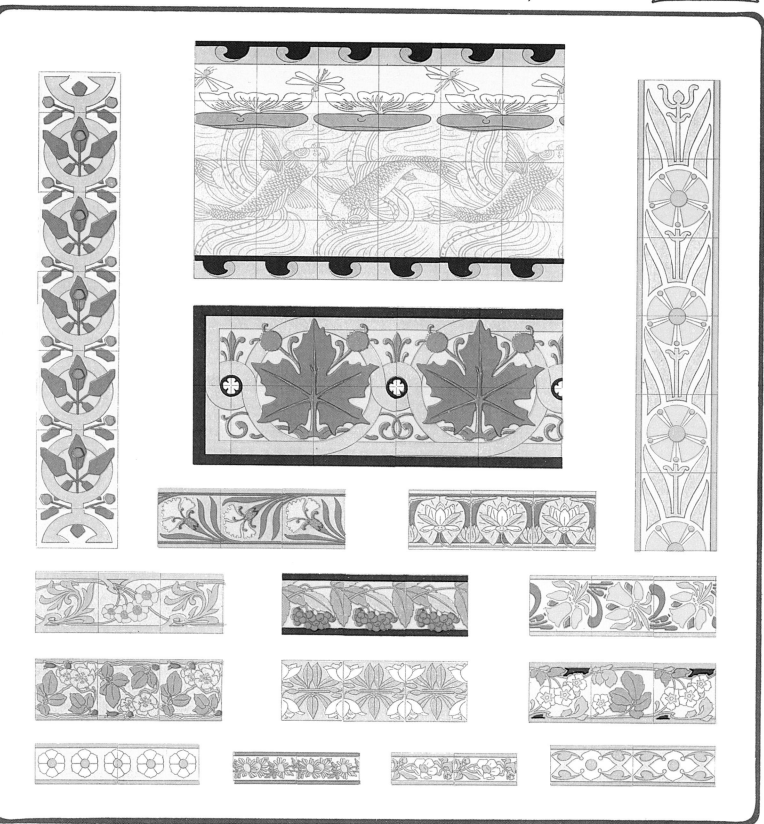

28, RUE DE PARADIS – PARIS

37. Friezes, borders and mountings in painted enamel

LES FAÏENCERIES DE SARREGUEMINES
❧ DIGOIN ET VITRY·LE·FRANÇOIS ❧

Gᵈ PRIX 1900

TÉLÉPHONE 258·70

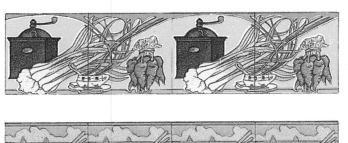
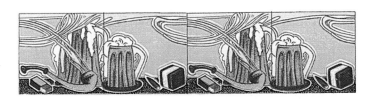
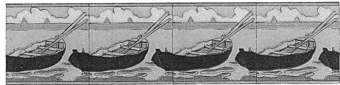
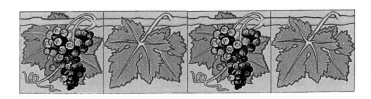
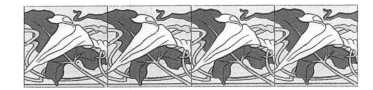
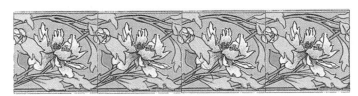
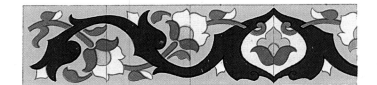
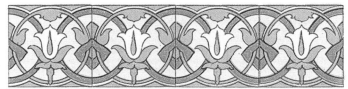
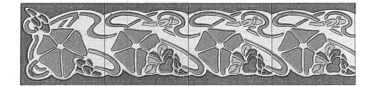
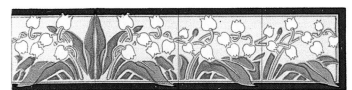
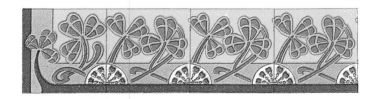
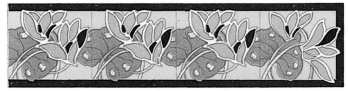
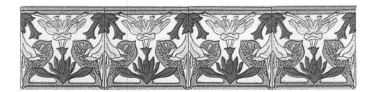
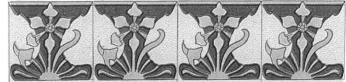

28, RUE DE PARADIS _ PARIS

38. Friezes in painted enamel

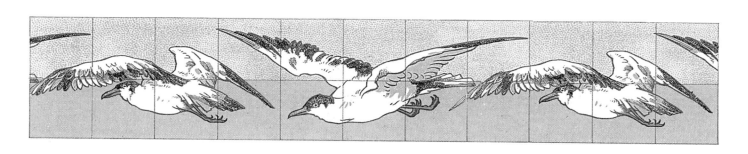

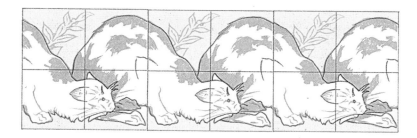

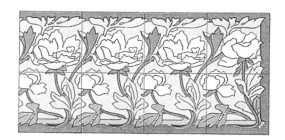

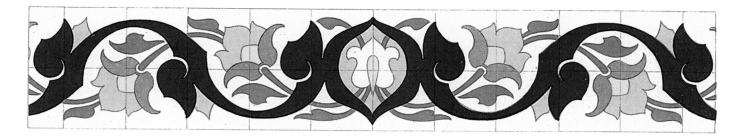

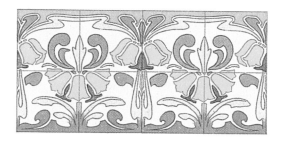

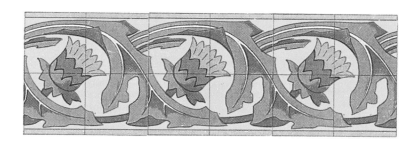

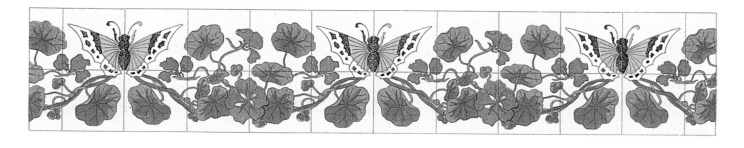

28, RUE DE PARADIS _ PARIS

39. Friezes in painted enamel

LES FAÏENCERIES DE SARREGUEMINES
DIGOIN ET VITRY·LE·FRANÇOIS

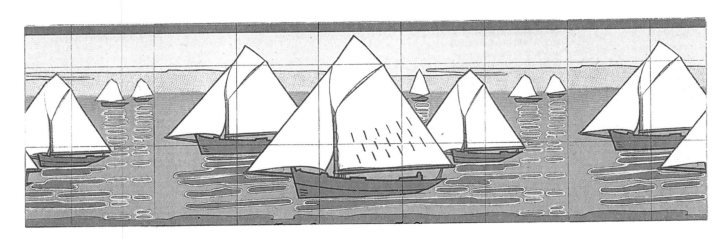

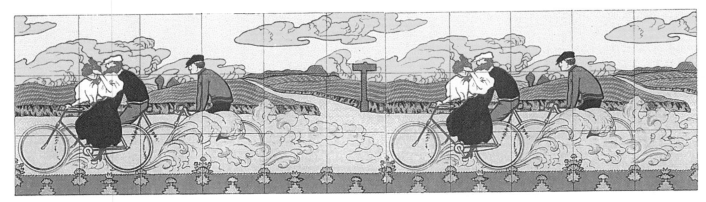

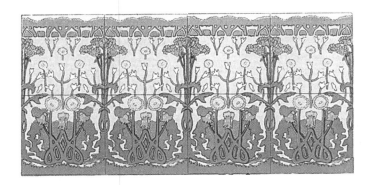
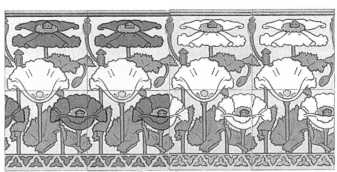

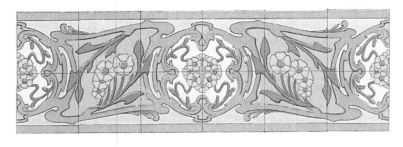
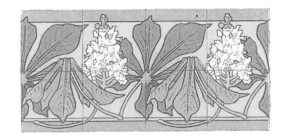

28, RUE DE PARADIS – PARIS

40. Friezes in painted enamel

LES FAÏENCERIES DE SARREGUEMINES
DIGOIN ET VITRY·LE·FRANÇOIS

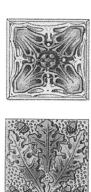
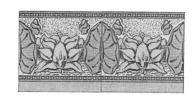

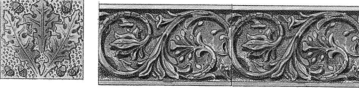

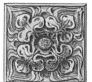

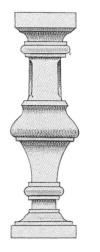
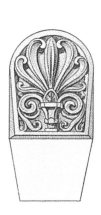
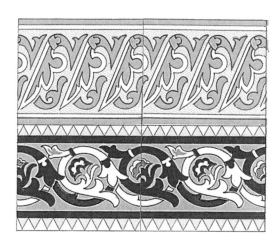
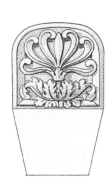
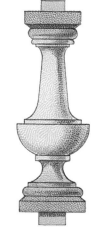

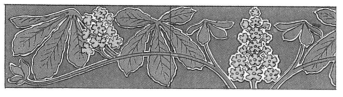
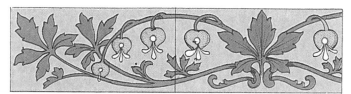

28, RUE DE PARADIS _ PARIS

41. Terra cotta friezes, panel, balusters and palmettes for architectural decoration

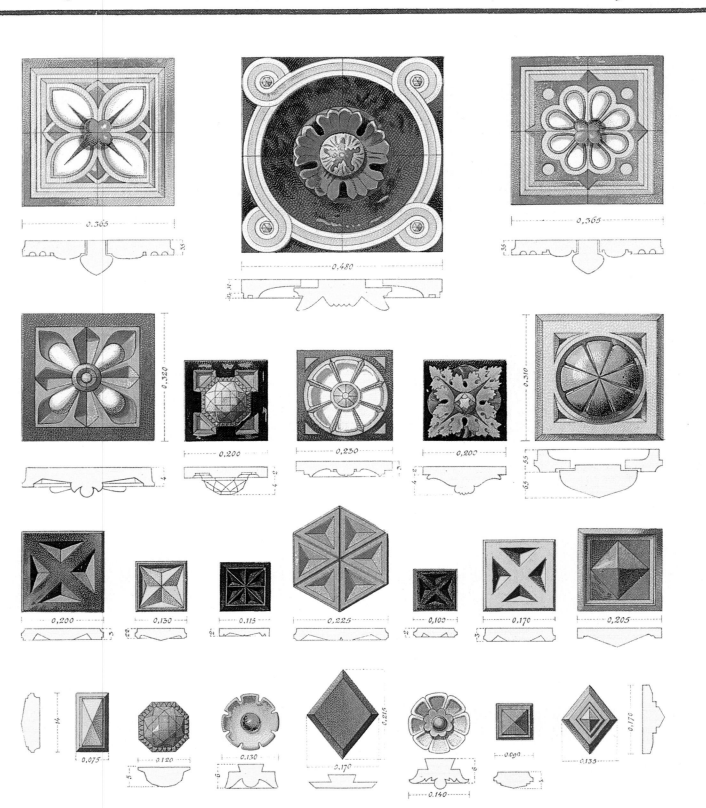

28, RUE DE PARADIS _ PARIS

42. Metopes and cabochons

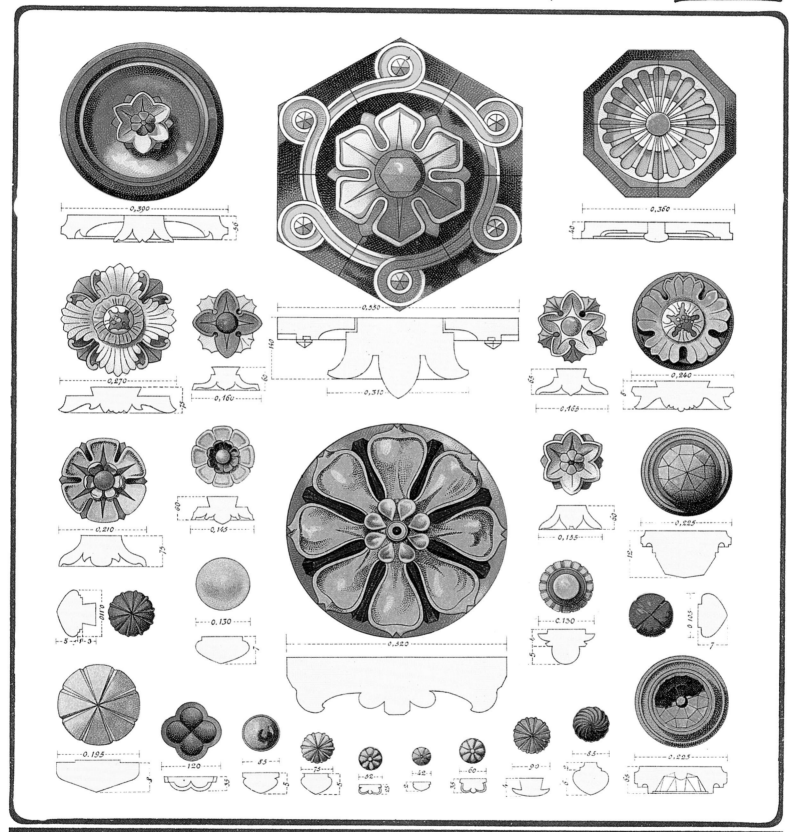

43. Cabochons